"The Christian is the one whose
imagination should fly beyond the stars."

IVP
CLASSICS

Art and the Bible

Two Essays

FRANCIS A. SCHAEFFER

FOREWORD BY MICHAEL CARD

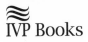

IVP Books

An imprint of InterVarsity Press
Downers Grove, Illinois

InterVarsity Press
P.O. Box 1400, Downers Grove, IL 60515-1426
World Wide Web: www.ivpress.com
E-mail: email@ivpress.com

*InterVarsity Press® is the book-publishing division of InterVarsity Christian Fellowship/USA®,
a student movement active on campus at hundreds of universities, colleges and schools of nursing
in the United States of America, and a member movement of the International Fellowship of
Evangelical Students. For information about local and regional activities, write Public Relations
Dept., InterVarsity Christian Fellowship/USA, 6400 Schroeder Rd., P.O. Box 7895, Madison,
WI 53707-7895, or visit the IVCF website at <www.intervarsity.org>.*

Design: Cindy Kiple
Images: Scala/Art Resource, NY

ISBN-10: 0-8308-3401-X
ISBN-13: 978-0-8308-3401-3

Printed in the United States of America ∞

Library of Congress Cataloging-in-Publication Data

Schaeffer, Francis A. (Francis August)
 [Art in the Bible]
 Art and the Bible / Francis A. Schaeffer.
 p. cm.
 ISBN-13: 978-0-8308-3401-3 (pbk.: alk. paper)
 ISBN-10: 0-8308-3401-X (pbk.: alk. paper)
 1. Arts in the Bible. 2. Christianity and art. I. Schaeffer,
 Francis A. (Francis August). Some perspectives on art. II. Title.
 BS680.A77S33 2007
 246—dc22

 2006030468

| **P** | 16 | 15 | 14 | 13 | 12 | 11 | 10 | 9 | 8 | 7 | 6 | 5 | 4 |
| **Y** | 19 | 18 | 17 | 16 | 15 | 14 | 13 | 12 | 11 | 10 | 09 | | |

Contents

121027

Foreword

And with truth comes beauty and with this beauty a freedom before God."

In 1812, Dr. Benjamin Rush wrote a letter of congratulations to his close friend John Adams. He had been encouraging Adams and Thomas Jefferson to renew their long fractured friendship. Adams had responded, offering an "olive branch" letter written to Jefferson on New Year's Day. Jefferson responded shortly afterward. Upon hearing the good news, an overjoyed Rush wrote back to Adams, "Some talked, some wrote, and some fought to promote and establish it [the American Revolution], but you and Mr. Jefferson *thought* for us all."

Two hundred years later, another revolution took place, a revolution of the Spirit. It was called the "Jesus Movement," and unless you were caught up in the midst of it, you might have difficulty appreciating what a liberating word, what a breath of fresh air *Art and the Bible* was. A lot of people talked, wrote and even fought over the Jesus Movement, but Francis Schaeffer did a good deal of thinking for us, and more importantly, he taught us how to think.

Almost as soon as the movement began it was plagued with confusion. While some of us were trying to embrace the gifts God was pouring out on the body, others were calling them a curse. They claimed that contemporary styles, even certain instruments (like the guitar) were not appropriate or acceptable in the church.

Into the midst of this confusion stepped a quirky, goateed man in lederhosen. He spoke words of faith and freedom. Into a world that had become suspicious of the beautiful Schaeffer reminded us that the Father of Jesus was also the God of beauty.

At a time when we needed concrete, biblical objectives, Schaeffer provided perspectives and struc-

tures (major and minor) while at the same time insisting again and again that it is our lives that are supposed to be the lived out works of art (*poiema*). We were free, he insisted, our imaginations were free. We were free to create, as long as we never forgot that we are slaves to Jesus.

Schaeffer moved freely from Heidegger to Eliot to Filippo Lippi to Luther, expecting those of us who weren't familiar with these creative giants to go look them up. In the process he exposed us to a wide scope of thinkers we would never have known otherwise. His insistence on the integration of content with vehicle and what he called "validity" provided a directive that cut through the confusing fog caused by all the dissension. But his encouragement was not a carte blanche; it was a defense of artists to the church and a challenge to the artists themselves to remain redemptively within the church.

This book, a primer on biblical creativity, sought to drum into us the idea that we create out of a worldview and that it is our responsibility to align that point of view with Scripture before we continue on. He encouraged artists to take seriously the lord-

ship of Christ in every aspect of their creative lives. He brought biblical clarity at a time when the movement badly needed it. He warned us that our creative struggle should and indeed would last a lifetime. My experience has shown that he was right. At a time when doors were being slammed in our faces he sought to open them, or at least to hand us a key. He liberated an entire generation of artists while at the same time placing us under the easy yoke of the authority of Scripture, everything under the Word of God

Perhaps you are thinking, *All that was almost a generation ago. What place does Schaeffer have today?* Though it might be true to repeat the worn out notion that "this book can speak to a whole new generation," that does not really say enough. Today, over thirty years after it was written, many of us believe a new movement is coming. What we believe and hope and trust is that the timing of this new edition of *Art and the Bible* is in accordance with a new revolution of the Spirit that is soon to come.

So, young artist, invest yourself in the truth of this little book. Open your eyes to the beauty that is un-

veiled through the Scriptures and the gospel of Jesus Christ. And finally, come alive to the freedom that is uniquely yours to create to the glory of God. *Think*.

Michael Card
Singer, songwriter and author of Scribbling in the Sand

ONE

Art in the Bible

W hat is the place of art in the Christian life? Is art—especially the fine arts of painting and music—simply a way to bring in worldliness through the back door? We know that poetry may be used to praise God in, say, the psalms and maybe even in modern hymns. But what about sculpture or drama? Do these have any place in the Christian life? Shouldn't a Christian focus his gaze steadily on "religious things" alone and forget about art and culture?

THE LORDSHIP OF CHRIST

As evangelical Christians we have tended to relegate

art to the very fringe of life. The rest of human life we feel is more important. Despite our constant talk about the lordship of Christ, we have narrowed its scope to a very small area of reality. We have misunderstood the concept of the lordship of Christ over the whole of man and the whole of the universe and have not taken to us the riches that the Bible gives us for ourselves, for our lives and for our culture.

The lordship of Christ over the whole of life means that there are no platonic areas in Christianity, no dichotomy or hierarchy between the body and the soul. God made the body as well as the soul and redemption is for the whole man. Evangelicals have been legitimately criticized for often being so tremendously interested in seeing souls get saved and go to heaven that they have not cared much about the whole man.

The Bible, however, makes four things very clear: (1) God made the whole man, (2) in Christ the whole man is redeemed, (3) Christ is the Lord of the whole man now and the Lord of the whole Christian life, and (4) in the future as Christ comes back, the body will be raised from the dead and the whole

man will have a whole redemption. It is within this framework that we are to understand the place of art in the Christian life. Therefore, let us consider more fully what it means to be a whole man whose whole life is under the lordship of Christ.

The conception of the wholeness of man and the lordship of man over creation comes early in Scripture. In Genesis 1:26-27, we read, "And God said, Let us make man in our image, after our likeness: and let them have dominion over the fish of the sea, and over the birds of the heavens, and over the cattle, and over all the earth, and over every creeping thing that creepeth upon the earth. And God created man in his own image, in the image of God created he him; male and female created he them." From the very beginning, therefore, man and woman, being created in the image of God (both of them!), were given dominion (lordship) over the whole of the created earth. They were the ones who bore the image of God and, bearing that image, they were to be in charge, to tend the garden, to keep it and preserve it before their own Lord. Of course, that dominion was spoiled by the historic, space-time Fall, and there-

fore it is no longer possible to maintain that dominion in a perfect fashion.

Yet, when a man comes under the blood of Christ, his whole capacity as man is refashioned. His soul is saved, yes, but so are his mind and body. As Christians we are to look to Christ day by day, for Christ will produce his fruit through us. True spirituality means the lordship of Christ over the total man.

There have been periods in the past when Christians understood this better than we have in the last few decades. A few years ago when I started to work out a Christian epistemology and a Christian concept of culture, many people considered what I was doing suspect. They felt that because I was interested in intellectual answers I must not be biblical. But this attitude represents a real poverty. It fails to understand that if Christianity is really true, then it involves the whole man, including his intellect and creativeness. Christianity is not *just* "dogmatically" true or "doctrinally" true. Rather, it is true to what is there, true in the whole area of the whole man in all of life.

The ancients were afraid that if they went to the

end of the earth they would fall off and be consumed by dragons. But once we understand that Christianity is true to what is there, true to the ultimate environment—the infinite, personal God who is really there—then our minds are freed. We can pursue any question and can be sure that we will not fall off the end of the earth. Such an attitude will give our Christianity a strength that it often does not seem to have at the present time.

But there is another side to the lordship of Christ, and this involves the total culture—including the area of creativity. Again, evangelical or biblical Christianity has been weak at this point. About all that we have produced is a very romantic Sunday school art. We do not seem to understand that the arts too are supposed to be under the lordship of Christ.

I have frequently quoted a statement from Francis Bacon who was one of the first of the modern scientists and who believed in the uniformity of natural causes in an open system.

He, along with other men like Copernicus and Galileo, believed that because the world had been created by a reasonable God they could therefore

pursue the truth of the universe by reason. There is much, of course, in Francis Bacon with which I would disagree, but one of the statements which I love to quote is this: "Man by the Fall fell at the same time from his state of innocence and from his dominion over nature. Both of these losses, however, can even in this life be in some part repaired; the former by religion and faith, the latter by the arts and sciences." How I wish that evangelical Christians in the United States and Britain and across the world had had this vision for the last fifty years!

The arts and the sciences do have a place in the Christian life—they are not peripheral. For a Christian, redeemed by the work of Christ and living within the norms of Scripture and under the leadership of the Holy Spirit, the lordship of Christ should include an interest in the arts. A Christian should use these arts to the glory of God, not just as tracts, mind you, but as things of beauty to the praise of God. An art work can be a doxology in itself.

Nonetheless, while the concept of the lordship of Christ over the whole world would seem to include the arts, many Christians will respond by saying that

the Bible has very little to say about the arts. More specifically, some people say that the Jews had no interest in art because of what the Scripture says in the Ten Commandments. But that is just what we cannot say if we read the Bible carefully. Still, because many Christians make this challenge, their view deserves to be considered and answered in some detail.

NO GRAVEN IMAGE

Those who feel that art is forbidden by the Scripture point first to the Ten Commandments: "Thou shalt not make unto thee a graven image, nor any likeness of any thing that is in heaven above, or that is in the earth beneath, or that is in the water under the earth: thou shalt not bow down thyself unto them, nor serve them; for I Jehovah thy God am a jealous God" (Ex 20:4-5). Isn't it clear, they say, that man is forbidden to make likenesses of anything, not just of God but anything in heaven or on the earth? Surely this leaves no place for art.

But before we accept this conclusion, we should look at another passage in the Law, which helps us to understand what the commandment in Exodus

actually means. "Ye shall make you no idols, neither shall ye rear you up a graven image, or a pillar [that is, a standing image or a statue], neither shall ye place any figured stone in your land to bow down unto it: for I am Jehovah your God" (Lev 26:1). This passage makes clear that Scripture does not forbid the making of representational art but rather the worship of it. Only God is to be worshiped. Thus the commandment is not against making art but against worshiping anything other than God and specifically against worshiping art. To worship art is wrong, but to make art is not.

ART AND THE TABERNACLE

One major principle of interpreting Scripture is that Scripture does not contradict itself. This is why it is important to note that on Mount Sinai God *simultaneously* gave the Ten Commandments and commanded Moses to fashion a tabernacle in a way which would involve almost every form of representational art that men have ever known. Let us look at this in more detail.

While Moses was on Sinai, God gave him specific

instructions concerning the way in which the tabernacle should be made. He commanded Moses to gather from the Israelites gold and silver, fine cloth and dyed ram skins, fine wood and precious gems, and so forth. Then God said, "According to all that I shew thee, the pattern of the tabernacle, and the pattern of all the furniture thereof, even so shall ye make it" (Ex 25:9). Where did the pattern come from? It came from God. This is reaffirmed a few verses later, where God said, "And see that thou make them after their pattern, which hath been shewed thee in the mount [or, as the Hebrew says, 'which thou wast caused to see']" (Ex 25:40). God himself showed Moses the pattern of the tabernacle. In other words, God was the architect, not man. Over and over in the account of how the tabernacle is to be made, this phrase appears: "And thou shalt make . . . " That is, God told Moses what to do in detail. These were commands, commands from the same God who gave the Ten Commandments.

What were some of them? There were, of course, many, but we will concentrate on those concerned with the art in the tabernacle, the very place of wor-

ship itself. First, we find this statement about the art in the Holy of Holies: "And thou shalt make two cherubim of gold; of beaten work shalt thou make them, at the two ends of the mercy-seat" (Ex 25:18). What are cherubim? They are part of the angelic host. What is being commanded? Simply this: A work of art is to be constructed. What kind of art? Representational art in the round. A statuary of representation of angels was to be placed in the Holy of Holies—the place where only once a year one man, the high priest, would go—and it was to be done by the command of God himself.

Some may say, "Yes, but this is very special because these are angels that are being pictured. There is a sort of religious subject matter. It's not ordinary art representing things on the earth." True enough. But we find that just outside the Holy of Holies lampstands are to be placed: "And thou shalt make a candlestick of pure gold: of beaten work shall the candlestick be made, even its base, and its shaft; its cups, its knops, and its flowers, shall be of one piece with it: and there shall be six branches going out of the sides thereof; three branches of the candlestick

out of the one side thereof, and three branches of the candlestick out of the other side: three cups made like almond-blossoms in one branch, a knop and a flower; and three cups made like almond-blossoms in the other branch, a knop and a flower: so for the six branches going out of the candlestick" (Ex 25:31-33), and the description goes on. Thus we have another work of art—a candlestick. And how is it decorated? Not with representations of angels, but with representations of nature, flowers, blossoms, things of natural beauty. And these are to be in the tabernacle at the command of God in the midst of the place of worship.

Later in Exodus, we find this description of the priests' garments: "And upon the skirts of it thou shalt make pomegranates of blue, and of purple, and of scarlet, round about the skirts thereof" (Ex 28:33). Thus, when the priest went into the Holy of Holies, he was to take with him on his garments a representation of nature, carrying that representation into the presence of God. Surely this is the very antithesis of a command against works of art.

But there is something further to note here. In na-

ture, pomegranates are red, but these pomegranates
were to be *blue, purple* and *scarlet.* Purple and scarlet
could be natural changes in the growth of a pome-
granate. But blue isn't. The implication is that there
is freedom to make something which gets its impe-
tus from nature but can be different from it and it too
can be brought into the presence of God. In other
words, art does not need to be "photographic" in the
poor sense of photographic!

It is tempting sometimes to read the Bible as a
"holy book," treating the historical accounts as if
they were upper-story situations that had nothing to
do with down-to-earth reality. But we must under-
stand that when God commanded these works of art
to be built, some artist had to make them. There are
two sides to art. It is creative, yes, but art also in-
volves the technical details of how things are to be
made. In Exodus 37:7 we are given something of
these technical details: "And he made two cherubim
of gold; of beaten work made he them at the two
ends of the mercy-seat." The cherubim on the ark
didn't suddenly appear out of the sky. Somebody
had to get his hands dirty, somebody had to work

out the technical problems. The very thing that a modern artist wrestles with, these artists had to wrestle with. We shall see more of this as we discuss the temple.

THE TEMPLE

The temple, like the tabernacle, was not planned by man. Once more, the Scripture insists that the plan derived from God. David, the chronicler says, gave Solomon "the pattern of all that he had by the Spirit" for the various parts of the temple (1 Chron 28:11-12). And verse 19 reads, "All this, said David, have I been made to understand in writing from the hand of Jehovah, even all the works of this pattern." David's experience with God regarding the temple was not just an upper-story religious experience. Part of his experience involved the propositional revelation of how the temple should be made. David knew how to build the temple because God told him. In fact, David said that God made him understand *in writing* what the temple was to look like. We are not told by what means this writing, this propositional revelation came, but we are told that David

by inspiration of God had such a writing which gave him the pattern of the building.

What, therefore, was to be in the temple? For one thing, the temple was to be filled with art work. "And he [Solomon] garnished [covered] the house with precious stones for beauty" (2 Chron 3:6). Notice this carefully: The temple was covered with precious stones *for beauty.* There was no pragmatic reason for the precious stones. They had no utilitarian purpose. God simply wanted beauty in the temple. God is interested in beauty.

Come with me to the Alps and look at the snow-covered mountains. There can be no question. God is interested in beauty. God made people to be beautiful. And beauty has a place in the worship of God.

Young people often point out the ugliness of many evangelical church buildings. Unfortunately, they are often right. Fixed down in our hearts is a failure to understand that beauty should be to the praise of God. But here in the temple which Solomon built under the leadership of God himself beauty was given an important place.

The chronicler goes on to say that Solomon "over-

laid also the house, the beams, the thresholds, and the walls thereof, and the doors thereof, with gold; and graved [carved] cherubim on the walls" (2 Chron 3:7). We talked above about the cherubim in the Holy of Holies; they were art in the round. Here is carving, bas relief. There was bas-relief everywhere you looked. And there was also art in the round: "And in the most holy house he made two cherubim of image work" (v. 10).

Then in verses 16 and 17 we read, "And he made chains in the oracle, and put them on the tops of the pillars; and he made a hundred pomegranates, and put them on the chains. And he set up the pillars before the temple, one on the right hand, and the other on the left." Here are two free-standing columns. *They supported no architectural weight and had no utilitarian engineering significance.* They were there only because God said they should be there as a thing of beauty. Upon the capitals of those columns were pomegranates fastened upon chains. Art work upon art work. If we understand what we are reading here, it simply takes our breath away. This is something overwhelmingly beautiful.

In 2 Chronicles 4, we are told how Solomon made a huge altar and also a "molten sea" (a pool or bath) that was about fifteen feet in diameter and, according to some estimates, may have had the capacity of just under 10,000 gallons. Under this sea and holding it up was "the likeness of oxen, which did compass it round about, for ten cubits, compassing the sea round about. The oxen were cast in two rows, cast when it was cast. It stood upon twelve oxen, three looking toward the north, and three looking toward the west, and three looking toward the south, and three looking toward the east: and the sea was set upon them above, and all their hinder parts were inward" (2 Chron 4:3-4). Here again is representational art in the round placed in the temple. Angels are represented by the bas-relief of cherubim, inanimate nature is represented in carvings of flowers and pomegranates, and animate nature is represented in the form of cast oxen. Representational art of non-religious subjects was thus brought into the central place of worship.

To some extent, it could be said that the oxen were functional since they held up the "sea." But what function would the following have? "And it [the mol-

ten sea] was a hand-breadth thick; and the brim thereof was wrought like the brim of a cup, like the flower of a lily" (v. 5). The sea was not to be plain, but to be carved with lilies simply to be beautiful.

In 1 Kings 7:29, we have an additional detail. It comes in the description of the panels on the ten bases of brass in the temple: "And on the panels that were between the ledges were lions, oxen, and cherubim." God is saying, "I'll even have lions in my house, carved lions, oxen and cherubim." Not for a pragmatic function, just for beauty.

We could, of course, continue to multiply the references to art in relationship to the temple. For example, 1 Kings 6:29 reads, "And he carved all the walls of the house round about with carved figures of cherubim and palm-trees and open flowers, within and without." This sounds much like what we have looked at above, but it brings into focus something different. Here cherubim, palm trees and flowers are put together. In other words, we have representational art of both the seen and the unseen world. I don't believe *cherubim* is a figure of speech. Cherubim have form and are real. In fact, I am look-

ing forward to seeing them some day. Yet, we may well ask, "How can you make a representation of something in the unseen world?" The answer is simple: It's easy if God tells you what they look like. The making of cherubim has something to do with propositional revelation. Ezekiel, for example, saw cherubim twice (Ezek 1:4-25; 3:12-13). There is nothing at all problematic in picturing cherubim if God shows you or tells you what they look like.

We saw how with the tabernacle the artist was required to solve certain technical problems. The same is true for the art in the temple: "In the plain of Jordan did the king cast them [the various art works that were to be in the temple], in the clay ground between Succoth and Zeredah" (2 Chron 4:17). Just as Michelangelo chipped with his hands the marble from the great Italian quarries, so the Hebrew artist cast the bronze in a particular geographical place, a place where the clay was just right to make a good form from his model. These Hebrew artists were not different from men today; both live in the same world and have to deal with all the technical realities of the various forms of art.

Secular Art

So far we have been concerned with art that is involved specifically with the worship of God, whether its subject is angels or nature. And it is clear that since all this art was God-commanded, specifically religious subjects are not necessary for art. The factor which makes art Christian is not that it necessarily deals with religious subject matter.

In 1 Kings 10 we learn something about the secular art of Solomon's day, for here Solomon's throne is described. "Moreover the king made a great throne of ivory, and overlaid it with the finest gold. *There* were six steps to the throne, and the top of the throne was round behind; and *there* were stays on either side by the place of the seat, and two lions standing beside the stays. And twelve lions stood there on the one side and on the other upon the six steps: there was not the like made in any kingdom" (1 Kings 10:18-20). Every time I read this description I am intrigued. I would like to have seen this magnificent work of art—"ivory overlaid with the finest gold" and guarded by two lions by the side of the throne and twelve lions on the stairway to the throne.

Some scholars who have wondered why the two lions and the twelve lions are mentioned separately have suggested that the two lions at the top were alive and the other twelve were cast. We cannot be sure whether that is the case or not, but just imagine it, for a moment: Imagine yourself Solomon, sitting up there with the two lions roaring away on *either* side of you, chained *securely,* no doubt, but what a throne! What a piece of secular art!

JESUS' USE OF ART

If anyone is still troubled concerning the Bible and representational art, then he should consider what the Bible says about the brazen serpent that Moses lifted up in the wilderness. You will recall that while the children of Israel were wandering in the desert they complained to Moses about the lack of bread and water. God then sent "fiery serpents among the people, and they bit the people; and much of the people died" (Num 21:6). So the Israelites came to Moses, confessing that they had sinned and asking Moses to pray that God would take the serpents away. God then replied to Moses' prayer: "Make thee a fiery serpent, and

set it upon a standard: and it shall come to pass, that everyone that is bitten, when he seeth it, shall live" (v. 8). Moses obeyed this command and those who looked upon the "serpent of brass" lived.

The striking thing is that Jesus used this incident and this work of art as an illustration of his coming crucifixion: "And as Moses lifted up the serpent in the wilderness, even so must the Son of man be lifted up; that whosoever believeth may in him have eternal life" (Jn 3:14-15). What was Jesus using as his illustration? A work of art.

But then perhaps someone will say, "Yes, but they smashed it. Hezekiah broke it up in 2 Kings 18:4." That's true. In fact, God was even pleased with its destruction. But why did Hezekiah smash the brazen serpent? "And he [Hezekiah] brake in pieces the brazen serpent that Moses had made; for unto those days the children of Israel did burn incense to it." Did he smash it because it was a work of art? Of course not, because God had commanded Moses to make it. He smashed the work of art because men had made it an idol. What is wrong with representational art is not its existence but its wrong uses.

POETRY

We have been concerned thus far solely with repre-
sentational art, but the Bible is concerned with other
art forms as well. The most obvious is poetry. When
we think of poetry in the Bible, we think immedi-
ately of the psalms. But there is much Jewish poetry
elsewhere, and not all of it concerns specifically reli-
gious subjects. For example, 2 Samuel 1:19-27 is a
secular ode, a poem by David to the praise of Saul
and Jonathan as national heroes.

Later in 2 Samuel we are told that David wrote his
psalms under the leadership and inspiration of the
Holy Spirit:

> David the son of Jesse sayeth,
> And the man who was raised on high sayeth,
> The anointed of the God of Jacob,
> And the sweet psalmist of Israel:
> The Spirit of Jehovah spake by me,
> And his word was upon my tongue.
> (2 Sam 23:1-2)

Acts 2:25-31 confirms the fact that David was a
prophet. So we might paraphrase David as follows:

"Yes, I was a prophet. I was a forth-teller of God. And how did I write? Well, I wrote my poetry under the leadership of the Holy Spirit." We must not think that David was a prophet only when he wrote prose, for his poetry is just as inspired. How then can we say, or have even the slightest inclination to feel, that God despises poetry?

Interestingly enough, we have in the Septuagint, the Greek version of the Old Testament Scriptures that dates back to the second or third century B.C., a record of a psalm that is not in our Bible. There is a question, of course, whether it is a real psalm of David, but it sounds like David. We do not need to think that everything that David wrote was "inspired by God" the way what is in the Bible is inspired. So even if this is a genuine psalm of David it is probably not inspired in that sense. Certainly not all art is God speaking as a muse through the artist. Rather, it is the mannishness of man that creates. The artist as a man does not disappear, leaving the muse alone to speak. We can consider the following psalm from the Septuagint, therefore, to be David writing a piece of poetry as a piece of poetry.

I was small among my brethren
and youngest in my father's house.
I tended my father's sheep.
My hands formed a musical instrument
and my fingers tuned a psaltery.
And who shall tell my Lord?
The Lord himself, he himself hears.
He sent forth his angel
and he took me from my father's sheep.
And he anointed me with the oil of his
 anointing.
My brothers were handsome and tall,
but the Lord did not take pleasure in them.
I went forth to meet the Philistine
and he cursed me by his idols.
But I drew his own sword and beheaded him
and removed reproach from the children
 of Israel.

That certainly sounds like David. David pictures
himself as a young boy out on the hillside tending
his sheep. And what does he do? He is the artist. He
takes a piece of wood and shapes it to make a harp;
"my hands formed a musical instrument." As we

shall see, the Bible says that David as a craftsman later made the instruments that were used in the temple worship.

But David was also a musician. His "fingers tuned a psaltery." Like a man tuning his violin, David prepared his instrument for playing. The writing of poetry, the making of a beautiful instrument, the tuning of it so that its music can be filled with beauty—David did all these things as a spiritual exercise to the praise of God.

There is something exciting here. How can art be sufficiently meaningful? If it is offered up merely before men, then it does not have a sufficient integration point. But it can be offered up before God. David says, "And who shall tell my Lord?" That is, "Who shall tell my Lord that I made a beautiful instrument, who will tell him that I tuned the psaltery, who will tell him that I have written this poetry? Who will tell him about my song?" Then David responds, "The Lord himself, he himself hears." Nobody had to go and tell God. God knew. So the man who really loves God, who is working under the lordship of Christ, could write his poetry, compose

his music, construct his musical instruments, fash-
ion his statues, paint his pictures, even if no man
ever saw them. He knows God looks upon them.

So you might say to David, "David, why do you
sing? Just to amuse yourself? Only the little white-faced
sheep will hear." And David will reply, "Not at all. I'm
singing and the God of heaven and earth—he hears my
song and that's what makes it so worthwhile."

Art can of course be put into the temple. But it
doesn't have to be put into the temple in order to be
to the praise of God.

One of the most striking secular poems in the
Bible is the Song of Solomon. Many Christians in the
past have felt that this poem represents the love of
Christ for his church. The poem can in fact be inter-
preted in this way. But we must never reduce it solely
to the picture of this relationship. It depicts the rela-
tionship between Christ and the church because
every proper relationship between a man and a
woman is an illustration of the relationship between
Christ and the church. The fact is that God made the
love of a man for a woman to be representational of
the love of God for his people, of the bridegroom for

the bride, of Christ for his church. But in the Song of Solomon God takes a poem that expresses in great antiphonal strength the love of a man for a woman and a woman for a man, and places it in the Word of God. This kind of poetry, just like the psalms, can also represent something wonderful. How beautiful a praise to God this poem is! In one way, its placement in the Bible is parallel to the sort of secular art that we noticed on Solomon's throne, but it is more significant because this poem is put into the Scripture as Scripture itself.

How often do Christians think of sexual matters as something second-rate. Never, never, never should we do so according to the Word of God. The whole man is made to love God; each aspect of man's nature is to be given its proper place. That includes the sexual relationship, that tremendous relationship of one man to one woman. At the very beginning God brought Eve to man. A love poem can thus be beautiful. So if you are a young man or a young woman and you love a girl or you love a boy, you may indeed write beautiful love poetry. Don't be afraid. That too can be a praise to God. And when

the two people are Christians it can be a conscious doxology.

Before passing on to other art forms, I would like to simply reemphasize that even though it uses a different poetic form than English does, Hebrew poetry demands strict literary discipline. In fact, Hebrew poetry is probably much harder to write than Anglo-Saxon poetry. And just as an artist, a craftsman, was required to work with precision as he cast the bronze statues or carved the bas-relief on the walls of the temple, so the Hebrew poet had to be careful with the technical aspects of his poetry and strive for technical excellence. And in the striving for excellence comes a way to praise God too.

MUSIC

Music is another art form which the Bible does not ignore. One of the most fantastic pieces of musical art must have been the song the Hebrews sang after they were rescued from Pharaoh's army. Exodus 15 gives us that song. Think of this great host of Israelites—hundreds of thousands of people—gathered on the far side of the Red Sea and singing an antiph-

onal song—a work of art. "And Miriam the prophetess, the sister of Aaron, took a timbrel in her hand; and all the women went out after her with timbrels and with dances. And Miriam answered them, Sing ye to Jehovah, for he hath triumphed gloriously; The horse and his rider hath he thrown into the sea" (Ex 15:20-21). Here we have the men singing the stanza (these are given in Ex 15:1-18) and the women led by Miriam singing the chorus. Think of the joy of deliverance from oppression and think of what a scene this music-making must have been.

But there was also music in the temple. We are told in 1 Chronicles 23:5 that "four thousand praised Jehovah with the instruments which I made, said David, to praise therewith." Four thousand! A song rang out from four thousand at once. And the chronicler adds, "And David divided them into courses [divisions] according to the sons of Levi: Gershon, Kohath, and Merari" (v. 6). In other words, David divided the singers into parts, making what we would call a chorus. And art breaks forth with all its beauty, all its strength, all its communication and all its glory.

From the time of Hezekiah comes a scene I love to picture. Hezekiah had had the temple cleansed and the worship reformed according to the law of God which had been set aside for so long. And then, while the sacrifices were being offered, Hezekiah "set the Levites in the house of Jehovah with cymbals, psalteries, and with harps [notice the various instruments], according to the commandment of David, and of Gad the king's seer, and Nathan the prophet; for the commandment was of Jehovah by his prophets. And the Levites stood with the instruments of David, and the priests with the trumpets" (2 Chron 29:25-26). Then Hezekiah commanded that the offerings be burnt upon the altar: "And when the burnt offering began, the song of Jehovah began also, and the trumpets, together with the instruments of David king of Israel. And all the assembly worshipped, and the singers sang, and the trumpeters sounded; all this continued until the burnt offering was finished" (vv. 27-28). A tremendous use of music and art, again all at the commandment of God through his prophets.

I suppose my favorite piece of music is Handel's

Dettingen Te Deum. I have a record of this music (Fontana 875-015-CY) in which all the instruments are playing, and I want to tell you it is marvelous. I've played the grooves off of it. Every time I read this section in 2 Chronicles, I think of the *Dettingen Te Deum* and of the fact that what was going on in the time of Hezekiah must have been ten times greater. Trumpets, cymbals, psalteries, harps, all the various instruments of David—music upon music, art upon art—all pouring forth, all pointing up the possibility of creativity in praise of God, all carried to a high order of art at God's command. And when you begin to understand this sort of thing, suddenly you can begin to breathe, and all the terrible pressure that has been put on us by making art something less than spiritual suddenly begins to disappear. And with this truth comes beauty and with this beauty a freedom before God.

We should note that with regard to the temple all of the art worked together to form a unity. The whole temple was a single work of architecture, a unified unit with free-standing columns, statuary, bas-relief, poetry and music, great huge stones,

beautiful timbers brought from afar. It's all there. A
completely unified work of art to the praise of God.
Surely this has something to say to us about archi-
tecture, and we ought to be asking the Lord how we
can produce this kind of praise to God today.

DRAMA AND THE DANCE

Two more art forms are mentioned in the Scripture.
The first is drama. In Ezekiel we read, "Thou also,
son of man, take thee a tile, and lay it before thee,
and portray upon it a city, even Jerusalem: and lay
siege against it, and build forts against it, and cast up
a mound against it; set camps also against it, and
plant battering rams against it round about. And
take thou unto thee an iron pan [or, flat plate] and
set it for a wall of iron between thee and the city: and
set thy face toward it, and it shall be besieged, and
thou shalt lay siege against it. This shall be a sign to
the house of Israel" (Ezek 4:1-3). What was this? It
was a simple drama. The "tile" had the skyline of
Jerusalem drawn upon it as a simple backdrop, so
that the people could not miss what Ezekiel was por-
traying. Jerusalem was to be besieged, and the warn-

ing was taught to the people by the command of
God, in a drama.

Let us notice: It is not that *every* use of any of
these art forms is automatically right, but that they
are not wrong per se. Ezekiel was asked to enact this
drama each day for over a year. For these long
months he portrayed a work of drama before the
backdrop in order that Israel would understand that
God was going to bring down judgment.

The second art form, the dance, is mentioned in
Psalm 149:3 in which Israel is encouraged to praise
God: "Let them praise his name in the dance: Let
them sing praises unto him with the timbrel and
harp." Some may reply, "Well, in the margin of my
Bible it says that maybe it isn't the dance but rather
the 'pipe,' and I like that better." But I doubt that
translation. Psalm 150:4-5 says, "Praise him with
timbrel and dance: Praise him with stringed instru-
ments and pipe. Praise him upon the loud cymbals:
Praise him upon the high sounding cymbals."

Two historical portions of the Bible show that
God was pleased with people dancing: Exodus
15:20 says that Miriam as prophetess went out "with

timbrels and with dances." And in 2 Samuel 6:14-16
we are told, "And David danced before Jehovah with
all his might; and David was girded with a linen
ephod." Imagine David bringing the ark of God into
his city—a very high moment indeed among the
Jews. The ark which had been outside is now being
brought in, and David is filled with joy as he wor-
ships God. It is interesting, by the way, that David
was clothed with an ephod. This means that he was
not dancing naked as was common among the hea-
then. Nonetheless, when David's wife saw it she
didn't like it (v. 16). Yet God liked it, and David's *wife*
was reproved for reproving David.

ART AND HEAVEN

Revelation 15:2-3 reads, "And I saw as it were a sea
of glass mingled with fire; and them that come off
victorious from the beast, and from his image, and
from the number of his name, standing by the sea of
glass, having harps of God. And they sing the song of
Moses the servant of God, and the song of the Lamb,
saying, Great and marvelous are thy works, O Lord
God, the Almighty; righteous and true are thy ways,

thou King of the ages." Art does not stop at the gate of heaven. Art forms are carried right into heaven. Is there any platonic separation here? Not a bit.

In the art museum at Neuchatel are three great murals by Paul Robert which for over eighty years have borne testimony to all the people of Neuchatel that Christ is coming again. One of the murals testifies to the fact that Christ has a relationship to agriculture, another to the fact that Christ has a relationship to industry. But the third one is the greatest. It depicts the relationship between Christ, the intellectual life and the arts. Paul Robert, a Swiss artist who was a real man of God, understood this relationship very well.

In the background of this mural he pictured Neuchatel, the lake on which it is situated and even the art museum which contains the mural. In the foreground near the bottom is a great dragon wounded to the death. Underneath the dragon is the vile and the ugly—the pornographic and the rebellious. Near the top Jesus is seen coming in the sky with his endless hosts. On the left side is a beautiful stairway, and on the stairway are young and beautiful men and women

carrying the symbols of the various forms of art—
architecture, music and so forth. And as they are car-
rying them up and away from the dragon to present
them to Christ, Christ is coming down to accept
them. Paul Robert understood Scripture a lot better
than many of us. He saw that at the second coming
the lordship of Christ will include everything.

But he also knew that if these things are to be
carried up to the praise of God and the lordship of
Christ at the second coming, then we should be of-
fering them to God now. In the same picture he
portrayed the city of Neuchatel, the beautiful lake
and the art museum itself: The art museum of Neu-
chatel and its works of art should be to the praise
of Christ *now*. The reality of the future has meaning
for the present!

Do we understand the freedom we have under
the lordship of Christ and the norms of Scripture? Is
the creative part of our life committed to Christ?
Christ is the Lord of our whole life and the Christian
life should produce not only truth—flaming truth—
but also beauty.

Some Perspectives on Art

All of us are engaged daily with works of art, even if we are neither professional nor amateur artists. We read books, we listen to music, we look at posters, we admire flower arrangements. *Art,* as I am using the word, does not include just "high art," that is, painting, sculpture, poetry, classical music, but also the more popular expressions—the novel, the theater, the cinema, popular music and rock. In fact, there is a very real sense in which the Christian life itself should be our greatest work of art. Even for the great artist, the most crucial work of art is his life.

In what follows I wish to develop a Christian per-

spective on art in general. How should we as creators and enjoyers of beauty comprehend and evaluate it? There are, I believe, at least eleven distinct perspectives from which a Christian can consider and evaluate works of art. These perspectives do not exhaust the various aspects of art. The field of aesthetics is too rich for that. But they do cover a significant portion of what should be a Christian's understanding in this area.

THE ART WORK AS AN ART WORK

1. The first is the most important: *A work of art has a value in itself.* For some this principle may seem too obvious to mention, but for many Christians it is unthinkable. And yet if we miss this point, we miss the very essence of art. Art is not something we merely analyze or value for its intellectual content. It is something to be enjoyed. The Bible says that the art work in the tabernacle and the temple was for beauty.

How should an artist begin to do his work as an artist? I would insist that he begin his work as an artist by setting out to make a work of art. What that would mean is different in the sculpture and poetry

for example, but in both cases the artist should be setting out to make a work of art.

As a Christian we know why a work of art has value. Why? First, because a work of art is a work of creativity, and creativity has value because God is the Creator. The first sentence in the Bible is the declaration that the Creator created: "In the beginning God *created* the heavens and the earth." So too the first words of the prologue to the Gospel of John: "In the beginning was the Word, and the Word was with God, and the Word was God. . . . All things were made through him; and without him was not anything made that hath been made" (Jn 1:1, 3). Therefore, the first reason that creativity has value is that God is the Creator.

Second, an art work has value as a creation because man is made in the image of God, and therefore man not only can love and think and feel emotion but also has the capacity to create. Being in the image of the Creator, we are called upon to have creativity. In fact, it is part of the image of God to be creative, or to have creativity. We never find an animal, non-man, making a work of art. On the other hand,

we never find men anywhere in the world or in any culture in the world who do not produce art. Creativity is a part of the distinction between man and non-man. All people are to some degree creative. Creativity is intrinsic to our mannishness.

But we must be careful not to reverse this. Not every creation is great art. Nor is all that man makes good either intellectually or morally. So, while creativity is a good thing in itself, it does not mean that everything that comes out of man's creativity is good. For while man was made in the image of God, he is fallen. Furthermore, since men have various gifts and talents, everyone cannot create everything equally well. However, the main point is that creativity as creativity is a good thing as such.

When I was younger, I thought it was wrong to use the word *create* in reference to works of art. I thought it ought to be used solely in relation to what God can do. Later, I saw that I was desperately wrong; I am now convinced that it is important to understand that both God and man create. Both make something. The distinction is this: God, because he is infinite, can create out of nothing by his

spoken word. We, because we are finite, must create from something else that has already been created. Yet the word *create* is appropriate, for it suggests that what man does with what is already there is to make something new. Something that was not there before, something that began as an unmannish part of reality, is transformed by the mannishness of man and now reflects that mannishness.

I am convinced that one of the reasons men spend millions in making art museums is not just so that there will be something "aesthetic" but because the art works in them are an expression of the mannishness of man himself. When I look at the pre-Columbian silver or African masks or ancient Chinese bronzes, not only do I see them as works of art but I see them as expressions of the nature and character of humanity. As a man, in a certain way they are myself, and I see there the outworking of the creativity that is inherent in the nature of man.

Many modern artists, it seems to me, have forgotten the value that art has in itself. Much modern art is far too intellectual to be great art. I am thinking, for example, of such an artist as Jasper Johns. Many

modern artists seem not to see the distinction be-
tween man and non-man, and it is a part of the lost-
ness of modern man that they no longer see value in
the work of art as a work of art.

I am afraid, however, that as evangelicals we have
largely made the same mistake. Too often we think
that a work of art has value only if we reduce it to a
tract. This too is to view art solely as a message for
the intellect.

There are, I believe, three basic possibilities con-
cerning the nature of a work of art. The first view is
the relatively recent theory of art for art's sake. This is
the notion that art is just there and that is all there is
to it. You can't talk about it, you can't analyze it, it
doesn't say anything. This view is, I think, quite mis-
guided. For one thing, no great artist functions on
the level of art for art's sake alone. Think, for exam-
ple, of the high Renaissance, beginning with Cima-
bue (c. 1240-1302) and leading through Giotto
(1267-1337), Masaccio (1401-1428) and all the way
up to Michelangelo (1475-1564) and Leonardo da
Vinci (1452-1519). All of these artists worked from
one of two viewpoints, and sometimes there was a

confusion between the two. They worked either from their notion of Christianity (which to us who hold a biblical viewpoint was often deficient) or from a Renaissance form of humanism. Florence, for example, where so many excellent works of art were produced, was a center for the study of Neo-Platonism. Some of the artists studied under Ficino (1433-1499), perhaps the greatest of the Neo-Platonists and influential throughout Europe.

It is also true that the great modern artists such as Picasso never worked for only art for art's sake either. Picasso had a philosophy which showed through in his paintings. It is true that many lesser artists now work, or try to work, in the milieu of art for art's sake, but the great masters did not.

The second, which I spoke of above, is that art is only an embodiment of a message, a vehicle for the propagation of a particular message about the world or the artist or man or whatever. This view has been held by Christians as well as non-Christians, the difference between the two versions being the nature of the message which the art embodies. But, as I have said, this view reduces art to an

intellectual statement and the work of art as a work of art disappears.

The third basic notion of the nature of art—the one I think is right, the one that really produces great art and the possibility of great art—is that the artist makes a body of work and this body of work shows his world view. No one, for example, who understands Michelangelo or Leonardo can look at their work without understanding something of their respective world views. Nonetheless, these artists began by making works of art, and then their world views showed through the body of their work. I emphasize the body of an artist's work because it is impossible for any single painting, for example, to reflect the totality of an artist's view of reality. But when we see a collection of an artist's paintings or a series of a poet's poems or a number of a novelist's novels, both the outline and some of the details of the artist's conception of life shine through.

How then should an artist begin to do his work? I would insist that he begin by setting out *to make a work of art*. He should say to himself, "I am going to

make a work of art." Perspective number one is that a work of art is first of all a work of art.

ART FORMS ADD STRENGTH
TO THE WORLD VIEW

2. Art forms add strength to the world view which shows through, no matter what the world view is or whether the world view is true or false. Think, for example, of a side of beef hanging in a butcher shop. It just hangs there. But if you go to the Louvre and look at Rembrandt's painting, *Side of Beef Hanging in a Butcher Shop,* it's very different. It's startling to come upon this particular work because it says a lot more than its title. Rembrandt's art causes us to see the side of beef in a concentrated way, and, speaking for myself, after looking and looking at his picture, I have never been able to look at a side of beef in a butcher shop with the superficiality I did before. How much stronger is Rembrandt's painting than merely the label, A Side of Beef.

In literature, there is a parallel. Good prose as an art form has something bad prose does not. Further, poetry has something good prose does not. We may

have long discussions on what is added, but the fact that there are distinct differences is clear. Even in the Bible the poetry adds a dimension lacking in the prose. In fact, the effect of any proposition, whether true or false, can be heightened if it is expressed in poetry or in artistic prose rather than in bald, formulaic statement.

Normal Definitions, Normal Syntax

3. *In all forms of writing, both poetry and prose, it makes a tremendous difference whether there is a continuity or a discontinuity with the normal definitions of words in normal syntax.* Many modern writers make a concerted effort to disassociate the language of their works from the normal use of language in which there is a normal definition of words and a normal use of syntax. If there is no continuity with the way in which language is normally used, then there is no way for a reader or an audience to know what the author is saying.

An artist can, of course, use language with great richness, fill his writing with figures of speech and hyperbole or play games with the syntax. The great

artist often does this, going far beyond a merely *rudimentary* use of normal grammar and normal definition of words. And in doing so he adds depth and dimension.

Shakespeare is the great example. We understand Shakespeare's dramas because he uses enough normal syntax and normal definitions of words so that there is a running story and a continuity between the running story and all of the artistic devices he uses. We know what Shakespeare is saying not because of the far-flung metaphors and beautiful verbal twists but because of the continuity they have with the story on the level of normal definitions and normal syntax. There is a firm core of straightforward propositions.

What is true in literature is also true in painting and sculpture. The common symbolic vocabulary that belongs to all men (the artists and the viewers) is the world around us, namely God's world. That symbolic vocabulary in the representational arts stands parallel to normal grammar and normal syntax in the literary arts. When, therefore, there is no attempt on the part of an artist to use this symbolic vocabulary at all, then communication is impossible

here too. There is then no way for anyone to know what the artist is saying. My point is *not* that making this sort of art is immoral or anti-Christian but rather that a dimension is lost.

Totally abstract art stands in an undefined relationship with the viewer, for the viewer is completely alienated from the painter. There is a huge wall between them. The painter and the viewer stand separated from each other in total alienation, a greater alienation than Giacometti could ever show in his alienated figures.

When Giacometti pictures the awful alienation of man, he makes figures which are alienated, but he is still living in God's world and is still using the common symbolic forms no matter how he distorts them. He plays with the vocabulary, but the vocabulary is still there. So there is a communication between Giacometti and me, a titanic communication. I can understand what he is saying and I cry.

In contrast to this there is a distinct limitation to totally abstract art. Like prose or poetry which has no contact with normal syntax and the normal definitions of words, it is a quarry out of which the observer

or the hearer has a personal emotional response.

ART AND THE SACRED

4. *The fact that something is a work of art does not make it sacred.* Heidegger in *What Is Philosophy?* came finally to the view that there are small beings, namely people, who verbalize and therefore we can hope that Being has some meaning. His great cry at the end of this book is to listen to the poet. Heidegger is not saying that we should listen to the content of what the poets say, because one can find two different poets who give absolutely opposite content and this doesn't matter. The poet became Heidegger's upper-story optimistic hope.

As Christians, we must see that just because an artist—even a great artist—portrays a world view in writing or on canvas, it does not mean that we should automatically accept that world view. Art may heighten the impact of the world view, in fact we can count on this, but it does not make something true. The truth of a world view presented by an artist must be judged on separate grounds than artistic greatness.

FOUR STANDARDS OF JUDGMENT

5. What kind of judgment does one apply, then, to a work of art? *I believe that there are four basic standards: (1) technical excellence, (2) validity, (3) intellectual content, the world view which comes through and (4) the integration of content and vehicle.*

I will discuss *technical excellence* in relationship to painting because it is easy to point out through this medium what I mean. Here one considers the use of color, form, balance, the texture of the paint, the handling of lines, the unity of the canvas and so forth. In each of these there can be varying degrees of technical excellence. By recognizing technical excellence as an aspect of an art work, we are often able to say that while we do not agree with such and such an artist's world view, he is nonetheless a great artist.

We are not being true to the artist as a man if we consider his art work junk simply because we differ with his outlook on life. Christian schools, Christian parents and Christian pastors often have turned off young people at just this point. Because the schools, the pastors and the parents did not make a distinction between technical excellence and content, the

whole of much great art has been rejected by scorn or ridicule. Instead, if the artist's technical excellence is high, he is to be praised for this, even if we differ with his world view. Man must be treated fairly as man. Technical excellence is, therefore, an important criterion.

Validity is the second criterion. By validity I mean whether an artist is honest to himself and to his world view or whether he makes his art only for money or for the sake of being accepted. If an artist makes an art work solely for a patron—whether that patron is the ancient noble, or the modern art gallery to which the artist wants access, or the modern art critics of the moment—his work does not have validity. The modern forms of "the patron" are more destructive than even that of the old noble.

To bring it down to earth, let's see what happens in the art form of preaching. There is many a pastor who does not have validity. Some preach for material gain and others in order to be accepted by their congregation. It is so easy to play to the audience, to adjust what one says or the way one says it to produce the kind of effect which will be most beneficial to the

preacher himself. And when one sees the issue in relationship to the gospel, the force of the dishonesty is especially obvious.

We can think of the contemporary dramatists whose future is in the hands of the critics of the passing moment. In drama, art, music and cinema, we have a set of New York and London critics who can make or break the artist. How easy it is to play to the critic and not to take one's art as a serious expression of what the artist himself wants to do.

The third criterion for the judgment of a work of art is its *content,* that which reflects the world view of the artist. As far as a Christian is concerned, the world view that is shown through a body of art must be seen ultimately in terms of the Scripture. The artist's world view is not to be free from the judgment of the Word of God. In this the artist is like a scientist. The scientist may wear a white coat and be considered an "authority" by society, but where his statements impinge upon what God has given us in Scripture, they come under the ultimate authority of his Word. An artist may wear a painter's smock and be considered almost a holy man, yet where his

work shows his world view, it must be judged by its relationship to the Christian world view.

I think we can now see how it is possible to make such judgments concerning the work of art. If we stand as Christians before a man's canvas and recognize that he is a great artist in technical excellence and validity—if in fact he is—if we have been fair with him as a man and as an artist, then we can say that his world view is wrong. We can judge this view on the same basis as we judge the views of anybody else—philosopher, common man, laborer, businessman or whatever.

Let's be more specific. The notion of Bohemian freedom which Jean Jacques Rousseau promulgated and which has been so prevalent in modern society has no place in Christian thinking. Rousseau was seeking a kind of autonomous freedom, and from him stemmed a group of "supermen" whose lives were lived above reason, as it were, and above the norms of society. For a long time this Bohemian life was taken to be the ideal for the artist, and it has come in the last few decades to be considered an ideal for more than the artist. From a Christian point

of view, however, this sort of life is not allowed. God's Word binds the great man and the small, the scientist and the simple, the king and the artist.

Some artists may not know that they are consciously showing forth a world view. Nonetheless, a world view usually does show through. Even those works which were constructed under the principle of art for art's sake often imply a world view. Even the world view that there is no meaning is a message. In any case, whether the artist is conscious of the world view or not, to the extent that it is there it must come under the judgment of the Word of God.

There is a corollary to this third criterion. We should realize that if something untrue or immoral is stated in great art it can be far more destructive and devastating than if it is expressed in poor art or prosaic statement. Much of the crude art, the common product of hippie communities and the underground press, is laden with destructive messages, but the art is so poor that it does not have much force. But the greater the artistic expression, the more important it is to consciously bring it and its world view under the judgment of Christ and the Bible.

The common reaction among many, however, is just the opposite. Ordinarily, many seem to feel that the greater the art, the less we ought to be critical of its world view. This we must reverse.

An example of the devastating effect of great art with non-Christian content occurs in Zen. In Zen, the world is nothing, man is nothing, everything is nothing, but Zen poetry says it beautifully, so much more beautifully than the underground press. Swearing in four-letter words, the underground press often declares that man is nothing, the world is nothing, nothing is nothing. And one thinks to himself, "Ah, but if it were said with some beauty, maybe there would be something." And then Zen comes along as a high art form and gives this message with beauty. And now you're dead twice.

There is a second corollary related to judging the content of an art work: It is possible for a non-Christian writer or painter to write and paint according to a Christian world view even though he himself is not a Christian. To understand this, we must distinguish between two meanings of the word *Christian*. The first and essential meaning is that a Christian is a man who

has accepted Christ as his Savior and has thus passed
from death to life, from the kingdom of darkness to
the kingdom of God by being born again. But if a
number of people really are Christians, then they
bring forth a kind of consensus that exists apart from
themselves, and sometimes non-Christians paint and
write within the framework of that consensus even
though they as individuals are not Christians.

There are, therefore, four kinds of people in the
realm of art. The first is the born-again man who
writes or paints within the Christian total world
view. The second is the non-Christian who expresses
his own non-Christian world view. The third is the
man who is personally a non-Christian but never-
theless writes or paints on the basis of the Christian
consensus by which he has been influenced. For ex-
ample, in another area, if one were to ask whether
Benjamin Franklin or Thomas Jefferson personally
were Christians, the answer, as best we can judge
from what they have said, is no. Nonetheless, they
produced something that had some sort of Christian
framework because they were producing it out of
the Christian consensus of Samuel Rutherford's *Lex*

Rex. Thus from a Christian framework, Jefferson and Franklin were able to write that men have certain inalienable rights, a notion derived from a specifically Christian world view.

The fourth person is the born-again Christian who does not understand what the total Christian world view should be and therefore produces art which embodies a non-Christian world view. In other words, just as it is possible for a non-Christian to be inconsistent and to paint God's world in spite of his personal philosophy, it is possible for a Christian to be inconsistent and embody in his paintings a non-Christian world view. And it is this latter which is perhaps the most sad.

The fourth criterion for judging a work of art involves how well the artist has *suited the vehicle to the message.* For those art works which are truly great, there is a correlation between the style and the content. The greatest art fits the vehicle that is being used to the world view that is being presented.

A recent example is found in T. S. Eliot's "The Waste Land." When Eliot published this in 1922, he became a hero to the modern poets, because for the

first time he dared to make the form of his poetry fit
the nature of the world as he saw it, namely, broken,
unrelated, ruptured. What was that form? A collec-
tion of shattered fragments of language and images
and allusions drawn seemingly haphazardly from all
manner of literature, philosophy and religious writ-
ings from the ancients to the present. But modern
poets were pleased, for they now had a poetic form
to fit the modern world view of unrelatedness.

The breakthrough in painting came in Picasso's
Demoiselles d'Avignon (1907), a painting which takes
its name from a house of prostitution in Barcelona.
Picasso began this work in the vein of other paintings
of the period but, as one critic describes it, Picasso
ended it as "a semi-abstract composition in which the
forms of the nudes and their accessories are broken
up into planes compressed into a shallow space."
More specifically, Picasso began on the left by paint-
ing the forms rather naturally, toward the middle he
painted more like Spanish primitives, and finally on
the right, as he finished his work, he painted the
women as only abstract forms and symbols or masks,
and thus succeeded in making monsters of his hu-

man subjects. Picasso knew what he was doing, and for a moment the world stood still. It was in fact so strong an expression that for a long time even his friends would not accept it. They didn't even want to look at it. Thus, in his painting of the women Picasso pictured the fractured nature of modern man. What T. S. Eliot did in his poetry, Picasso had already done in painting. Both men deserve high scores for suiting the vehicle to the message.

No art should be judged on the basis of this criterion alone, however. We should ultimately see all art works in the light of their technique, validity, world view and suiting of form to content.

ART CAN BE USED
FOR ANY TYPE OF MESSAGE

6. *Art forms can be used for any type of message from pure fantasy to detailed history.* That a work of art is in the form of fantasy or epic or painting does not mean that there is no propositional content. Just as one can have propositional statements in prose, there can be propositional statements in poetry, in painting, in virtually any art form.

Some years ago a theologian at Princeton commented that he did not mind saying the creeds, providing that he could sing them. What he meant was that so long as he could make them a work of art he didn't feel that he had to worry about the content. But this is both poor theology and poor aesthetics. A lyric can contain considerable theological content. An epic can be as emphatically (and accurately) historic as a straight piece of prose. *Paradise Lost,* for example, contains *many* statements which while artistically expressed are almost straight theology. Just because something takes the form of a work of art does not mean that it cannot be factual.

CHANGING STYLES

7. Many Christians, especially those unused to viewing the arts and thinking about them, reject contemporary painting and contemporary poetry not because of their world view but simply because they feel threatened by a new art form. It is perfectly legitimate for a Christian to reject a particular work of art intellectually, that is, because he knows what is being said by it. But it is another thing to reject the

work of art simply because the style is different from that which we are used to. In short: *Styles of art form change and there is nothing wrong with this.*

This sort of change is not only true of art forms, it is true of whole word systems. Chaucer wrote English and I write English. But surely there is quite a difference between them. Is it wrong for me to speak my kind of English rather than Chaucer's? Would you read what I wrote if I were writing in Chaucerian English?

As a matter of fact, change is one difference between life and death. There is no living language which does not undergo constant change. The languages which do not change, Latin, for example, are dead. As long as one has a living art, its forms will change. The past art forms, therefore, are not necessarily the right ones for today or tomorrow. To demand the art forms of yesterday in either word systems or art is a bourgeois failure. It cannot be assumed that if a Christian painter becomes "more Christian" he will necessarily become more and more like Rembrandt. This would be like saying that if the preacher really makes it next Sunday morning,

he will preach to us in Chaucerian English. Then we'll really listen!

Now, some may say, "Well, I don't want Chaucerian English, but I would certainly like King James English." I personally love King James English. It is still my language because I was educated in a day when it was one of the marks of the educated man to read it and the language of Shakespeare with facility. Reading it endlessly, I made it my own. But must I preach in King James English or be considered a failure? Must I *always* pray using King James English, the *thee's* and *thou's,* for example? To think so is a mark of a bourgeois mind. Christians must absolutely and consciously separate themselves from such thinking.

Not only will there be a change in art forms and language as time progresses, but there will be a difference in art forms coming from various geographical locations and from different cultures. Take, for example, Hebrew poetry. It has alliteration and parallelism and other such rhetorical forms, but it hardly ever rhymes. Does this mean it is not poetry? Or does it mean that most English poetry is wrong

because it rhymes? Must all poetry be frozen into the form of Hebrew poetry? Surely not. Rather, each art form in each culture must find its own proper relationship between world view and style.

For example, I may walk into a museum I have never been in before and enter a room without seeing its identifying plaque, and I may immediately say to myself, "Ah, this is Japanese art." How can I tell? From the style. The crucial question is, of course, should it show its Japaneseness? Shouldn't all art be Hebrew or some such? The answer is obviously no.

Then what about the Christian's art? Here three things should be stressed. First, Christian art today should be twentieth-century art. Art changes. Language changes. The preacher's preaching today must be twentieth-century language communication, or there will be an obstacle to being understood. And if a Christian's art is not twentieth-century art, it is an obstacle to his being heard. It makes him different in a way in which there is no necessity for difference. A Christian should not, therefore, strive to copy Rembrandt or Browning.

Second, Christian art should differ from country to country. Why did we ever force the Africans to use Gothic architecture? It's a meaningless exercise. All we succeeded in doing was making Christianity foreign to the African. If a Christian artist is Japanese, his paintings should be Japanese, if Indian, Indian.

Third, the body of a Christian artist's work should reflect the Christian world view. In short, if you are a young Christian artist, you should be working in the art forms of the twentieth century, showing the marks of the culture out of which you have come, reflecting your own country and your own contemporariness and embodying something of the nature of the world as seen from a Christian standpoint.

MODERN ART FORMS
AND THE CHRISTIAN MESSAGE

8. While a Christian artist should be modern in his art, he does face certain difficulties. First, we must distinguish carefully between style and message. Let me say firmly that *there is no such thing as a godly style or an ungodly style.* The more one tries to make such a distinction, the more confusing it becomes.

I remember being in Cambridge once at a symposium of Christians who were addressing themselves to the nature of Christian art and art forms. One of the Christian artists—a very fine organist—insisted that there was a Christian style in music. We discussed this at some length, forcing him to say just what the criterion for Christian style would be. He finally replied, "Christian music is music that you can tap your foot to." This is meaningless.

Yet, while there is no such thing as a godly or ungodly style, we must not be misled or naive in thinking that various styles have no relation whatsoever to the content or the message of the work of art. Styles themselves are developed as symbol systems or vehicles for certain world views or messages. In the Renaissance, for example, one finds distinctively different styles from those which characterize art in the Middle Ages. It does not take much education in the history of art to recognize that what Filippo Lippi was saying about the nature of the Virgin Mary is different from what was being said in paintings done before the Renaissance. Art in the Renaissance became more natural and less iconographic. In our

own day, men like Picasso and T. S. Eliot developed new styles in order to speak a new message.

There is a parallel in language itself. Sanskrit, I am told, developed as a perfect vehicle for Hindu philosophy. And I am told it is a very poor vehicle for the Christian message. As a matter of fact I have heard some Sanskrit scholars say that they don't think Christianity could even be preached in Sanskrit. I am no authority on this, but they may be right. It is interesting, for example, that both English and German were codified in their modern forms around the Christian message. The German language was made up of various dialectical forms when Luther translated the Bible. At that point, the German language was set down in a form which became standard. Luther's German became the literary German. In England, the early translations of the Bible, summed up supremely in the King James version, did the same thing for the English language. This meant that Christianity could be easily taught as long as the generally accepted meaning of the words were the Christian meaning of the words.

In Japan, on the other hand, it is very difficult to

use the word *guilt* without a long explanation, be-
cause in Japan the word *guilt* grew up as a vehicle for
the Japanese concept of ceremonial uncleanliness.
Now if we have a word that means ceremonial un-
cleanliness as a vehicle and we try to explain true
moral guilt in the presence of a holy, personal God,
we have quite a task. We may have to use the word,
but we must then refashion its definition and be cer-
tain that the people to whom we are speaking under-
stand just how we are using the word. It must mean
something different than it did in the symbol system
out of which the word came.

There is the same dilemma in art styles and
forms. Think, for example, of T. S. Eliot's form of
poetry in "The Waste Land." The fragmented form
matches the vision of fragmented man. But it is in-
triguing that after T. S. Eliot became a Christian,
for example in "The Journey of the Magi," he did
not use quite this same form. Rather, he adapted it
for the message he was now giving—a message
with a Christian character. But he didn't entirely
give up the form; he didn't go back to Tennyson;
rather, he adapted the form that he used in "The

Waste Land," changing it to fit the message that he
was now giving. In other words, T. S. Eliot the
Christian wrote somewhat differently than T. S.
Eliot the "modern man."

Therefore, while we must use twentieth-century
styles, we must not use them in such a way as to be
dominated by the world views out of which they
have arisen. Christianity is a message with its own
distinctive propositional content, not a set of "reli-
gious" truths in an upper story. The whole man is to
be addressed and this includes his mind as well as
his emotions and his aesthetic sensitivity. Therefore,
an art form or style that is no longer able to carry
content cannot be used to give the Christian mes-
sage. I am not saying that the style is in itself wrong
but that it has limitations. Totally fractured prose or
poetry cannot be used to give the Christian message
for the simple reason that it cannot carry intellectual
content and you can't preach Christianity without
content. The biblical message, the good news, is a
good news of content.

It is here that feedback is important in regard to
the style the artist chooses. Let us say, for example,

that you are playing in a Christian rock group, making an art form of rock. Suppose further that at the same time you are going into certain coffeehouses and using rock as a bridge to preach the Christian message. That's fine. But then you must be careful of the feedback. When you have finished playing, you must ask whether the people who have heard you play have understood what you have been doing. Have *they* heard your message clearly because you have used their modern idiom, or have they simply heard again what they have always heard when they have listened to rock because you used their form? Sometimes the content will get through, sometimes it will not. Not all situations will be the same; the immediate situation and what you are trying to do must be kept in mind.

The problem is just as prevalent in folk music as it is in rock. Joan Baez sings so beautifully, "You may call him Jesus, but I call him Savior." But as far as Joan Baez and most of her listeners are concerned, when she says, "I call him Savior," she is not calling him Savior in the way a Christian calls him Savior. She could be singing southern folk or country and

western or a Hindu lyric just as well. So when we come along and say, "My purpose is to sing folk so that I will be understood," we must find a way to make it clear that we are singing folk to convey a world view and not just to sing folk.

The form in which a world view is given can either weaken or strengthen the content, even if the viewer or reader does not in every case analyze this completely. In other words, depending upon the vehicle you use, something can come across that an audience does not notice and yet will be moving either in the direction of your world view or away from your world view. One must talk at length with the viewer or reader. And as a Christian adopts and adapts various contemporary techniques, he must wrestle with the whole question, looking to the Holy Spirit for help to know when to invent, when to adopt, when to adapt and when to not use a specific style at all. This is something each artist wrestles with for a lifetime, not something he settles once and for all.

In conclusion, therefore, often we will use twentieth-century art forms, but we must be careful to

keep them from distorting the world view which is distinctively ours as Christians. In one way styles are completely neutral. But in another way they must not be used in an unthinking, naive way.

THE CHRISTIAN WORLD VIEW

9. *The Christian world view can be divided into what I call a major and a minor theme.* (The terms *major* and *minor,* as I am using them, have no relationship to their use in music.)

First, the *minor theme* is the abnormality of the revolting world. This falls into two parts: (1) Men who have revolted from God and not come back to Christ are eternally lost; they see their meaninglessness in the present and they are right from their own standpoint. Neitzsche can say that God is dead and Sartre must follow along, showing that man is dead, and Sartre is right from his own perspective. (2) There is a defeated and sinful side to the Christian's life. If we are at all honest, we must admit that in this life there is no such thing as totally victorious living. In every one of us there are those things which are sinful and deceiving and, while we may see substantial healing,

in this life we do not come to perfection.

The *major theme* is the opposite of the minor; it is the meaningfulness and purposefulness of life. From the Christian viewpoint, this falls into two headings, metaphysics and morals. In the area of metaphysics (of being, of existence, including the existence of every man) God is there, God exists. Therefore, all is not absurd. Furthermore, man is made in God's image and so man has significance. With this comes the fact that love, not just sex, exists. True morals, as opposed to only conditioning, exist.

And creativity, as opposed to mechanical construction, exists. So therefore the major theme is an optimism in the area of being; everything is not absurd, there is meaning. But most important, this optimism has a sufficient base. It isn't suspended two feet off the ground, but rests on the existence of the infinite-personal God who exists and who has a character and who has created all things, especially man in his own image.

But there is also a major theme in relation to morals. Christianity gives a moral solution on the basis of the fact that God exists and has a character which is

the law of the universe. There is therefore an absolute in regard to morals. It is not that there is a moral law back of God that binds both God and man, but that God himself has a character and this character is reflected in the moral law of the universe. Thus when a person realizes his inadequacy before God and feels guilty, he has a basis not simply for the feeling but for the reality of guilt. Man's dilemma is not just that he is finite and God is infinite, but that he is a sinner guilty before a holy God. But then he recognizes that God has given him a solution to this in the life, death and resurrection of Christ. Man is fallen and flawed, but he is redeemable on the basis of Christ's work. This is beautiful. This is optimism. And this optimism has a sufficient base.

Notice that the Christian and his art have a place for the minor theme because man is lost and abnormal and the Christian has his own defeatedness. There is not only victory and song in my life. But the Christian and his art don't end there. He goes on to the major theme because there is an optimistic answer. This is important for the kind of art Christians are to produce. First of all, Christian art needs to rec-

ognize the minor theme, the defeated aspect to even the Christian life. If our Christian art only emphasizes the major theme, then it is not fully Christian but simply romantic art. And let us say with sorrow that for years our Sunday school literature has been romantic in its art and has had very little to do with genuine Christian art. Older Christians may wonder what is wrong with this art and wonder why their kids are turned off by it, but the answer is simple. It's romantic. It's based on the notion that Christianity has only an optimistic note.

On the other hand, it is possible for a Christian to so major on the minor theme, emphasizing the lostness of man and the abnormality of the universe, that he is equally unbiblical. There may be exceptions where a Christian artist feels it his calling only to picture the negative, but in general for the Christian, the major theme is to be dominant—though it must exist in relationship to the minor.

Modern art that does not depend on the Christian consensus has tended to emphasize only the minor theme. We look at the paintings hanging in the modern art galleries, and we are impressed by the pessi-

mistic analysis of contemporary man. There are, of course, some works of modern art which are optimistic. But the basis for that optimism is insufficient and, like Christian art which does not adequately emphasize the minor theme, it tends to be pure romanticism. The artist's work appears dishonest in the face of contemporary facts.

Finally, the Christian artist should constantly keep in mind the law of love in a world that is bent upon destruction. The Christian poet or painter may write or paint emphasizing the minor theme; at other times, and on other days, he may concentrate on the major theme. But our world at the end of the twentieth century has so much destruction without Christian artists so emphasizing the minor theme in the total body of their work that they add to the poorness and destruction of our generation. A Christian businessman who does not operate on the basis of compassion does not live within the biblical norms of economics, and the Christian artist who only concentrates on the abnormality of the world is likewise not living by the law of love.

There is a parallel in our conversation with men.

We must present both the law and the gospel; we ought not end with only the judgment of the law. Even though we may spend most of our time on the judgment of the law, love dictates that at some point we get to the gospel. And it seems to me that in the total body of his work the artist somewhere should have a sufficient place for the major theme.

THE SUBJECT MATTER OF CHRISTIAN ART

10. *Christian art is by no means always religious art, that is, art which deals with religious themes.* Consider God the Creator. Is God's creation totally involved with religious subjects? What about the universe? the birds? the trees? the mountains? What about the bird's song? and the sound of the wind in the trees? When God created out of nothing by his spoken word, he did not just create "religious" objects. And in the Bible, as we have seen, God commanded the artist, working within God's own creation, to fashion statues of oxen and lions and carvings of almond blossoms for the tabernacle and the temple.

We should remember that the Bible contains the Song of Solomon, the love song between a man and

a woman, and it contains David's song to Israel's national heroes. Neither subject is religious. But God's creation—the mountains, the trees, the birds and the birds' songs—are also non-religious art. Think about that. If God made the flowers, they are worth painting and writing about. If God made the birds, they are worth painting. If God made the sky, the sky is worth painting. If God made the ocean, indeed it's worth writing poetry about. It is worth man's while to create works upon the basis of the great works God has already created.

This whole notion is rooted in the realization that Christianity is not just involved with "salvation" but with the total man in the total world. The Christian message begins with the existence of God forever and then with creation. It does not begin with salvation. We must be thankful for salvation, but the Christian message is more than that. Man has a value because he is made in the image of God and thus man as man is an important subject for Christian art. Man as man—with his emotions, his feelings, his body, his life—this is an important subject matter for poetry and novels. I'm not talking here about man's

lostness but about his mannishness. In God's world the individual counts. Therefore, Christian art should deal with the individual.

Modern art often flattens man out and speaks in great abstractions; sometimes we cannot tell whether the subject is a man or a woman. Our generation has left little place for the individual. Only the mass of men remains. But as Christians we see things otherwise. Because God has created individual man in his own image and because God knows and is interested in the individual, individual man is worthy of our painting and of our writing.

Christian art is the expression of the whole life of the whole person who is a Christian. What a Christian portrays in his art is the totality of life. Art is not to be solely a vehicle for some sort of self-conscious evangelism.

If, therefore, Christianity has so much to say about the arts and to the artist, why is it that recently we have produced so little Christian art? I should think the answer would now be clear. We have not produced Christian art because we have forgotten most of what Christianity says about the arts.

Christians, for example, ought not to be threatened by fantasy and imagination. Great painting is not "photographic" in the poor sense of photographic. The Old Testament art commanded by God was not always "photographic." There were blue pomegranates on the robes of the priest when he went into the Holy of Holies. In nature there are no blue pomegranates. Christian artists do not need to be threatened by fantasy and imagination, for they have a basis for knowing the difference between them and the real world "out there." Epistemologically, as I have pointed out in *He Is There and He Is Not Silent,* Christian man has a basis for knowing the difference between subject and object. The Christian is the really free man—he is free to have imagination. This too is our heritage. The Christian is the one whose imagination should fly beyond the stars.

Moreover, a Christian artist does not need to concentrate on religious subjects. After all, religious themes may be completely non-Christian. The counter-culture art in the underground newspaper in which Christ and Krishna are blended:

Here is religious art par excellence. But it is completely anti-Christian. Religious subjects are no guarantee that a work of art is Christian. On the other hand, the art of an artist who never paints the head of Christ, never once paints an open tomb, may be magnificent Christian art. For some artists there is a place for religious themes, but an artist does not need to be conscience stricken if he does not paint in this area. Some Christian artists will never use religious themes. This is a freedom the artist has in Christ under the leadership of the Holy Spirit.

AN INDIVIDUAL ART WORK AND THE BODY OF AN ARTIST'S WORK

11. *Every artist has the problem of making an individual work of art and, as well, building up a total body of work.* No artist can say everything he might want to say or build everything he might want to build into a single work. It is true that some art forms, such as the epic and the novel, lend themselves to larger conceptions and more complex treatments, but even there not everything that an artist wants to do can be done in

one piece. Therefore, we cannot judge an artist's work from one piece. No art critic or art historian can do that. We must judge an artist's performance and an artist's world view on the basis of as much of that artist's work as we can.

There is a parallel here with the sermon. No single sermon can say everything that needs to be said. And no one can judge a minister's total theology or the content of his faith on the basis of a single sermon. The man who tries to put everything into one sermon is a very poor preacher indeed. Even the Bible is an extended body of books, and it cannot be read as if any one book or any one chapter included the whole; it must be read from beginning to end. And if that is true of the Word of God, how much more is it true of an artist's work!

If you are a Christian artist, therefore, you must not freeze up just because you can't do everything at once. Don't be afraid to write a love poem simply because you cannot put into it everything of the Christian message. Yet, if a man is to be an artist, his goal should be in a lifetime to produce a wide and deep body of work.

The Christian Life as a Work of Art

I would suggest that we take all of these perspectives on art and consider how they apply to our own Christian life. Perhaps it would be a good idea to read this essay again and specifically apply it to your life as a Christian. No work of art is more important than the Christian's own life, and every Christian is cared upon to be an artist in this sense. He may have no gift of writing, no gift of composing or singing, but each man has the gift of creativity in terms of the way he lives his life. In this sense, the Christian's life is to be an art work. The Christian's life is to be a thing of truth and also a thing of beauty in the midst of a lost and despairing world.

I V P
C L A S S I C S

In today's information age, we are deluged with content but yearn for wisdom that will transcend the moment. IVP Classics are significant, compact books that have stood the test of time, written by trusted authors who have shaped the lives of millions.